Untitled 24
The Friends of Photography

NEW LANDSCAPES

ACKNOWLEDGEMENTS

An irrepressible desire of photographers during the past century has been to capture the essence of the American landscape. Many of its remarkable land formations have been so over-exposed as to become cliches. Thus, the challenge for contemporary photographers, rather than to make another photograph of the same subject matter, is to restate the landscape issue in ways which are spiritually and visually meaningful. That this is still possible is attested to by the contributions of the eight photographers in this book.

These eight artists were selected from a group of 65 photographers whose work was shown at The Friends of Photography during the fall of 1980 in two successive exhibitions surveying recent landscape photography. I would like to thank each of those photographers for clarifying our understanding of current landscape concerns, particularly the eight photographers whose work was selected for reproduction here.

I would also like to thank Mark Johnstone, who contributed the perceptive introduction; David Featherstone and Mary Swanson, who, along with myself, wrote the biographical and critical statements that begin each photographer's portfolio; and Nancy Ponedel and Peggy Sexton, who typed the manuscript. Featherstone was also responsible for the copy editing; Peter Andersen for the design of the book. Dave Gardner and his staff at Gardner/Fulmer Lithography are a pleasure to work with; the use of laser scanner technology and the remarkable quality of their printing helps to illustrate the beauty of the original photographs.

James Alinder, Editor
The Untitled *Series*

UNTITLED 24

This publication is the twenty-fourth in a series of publications on serious photography by The Friends of Photography. Some previous issues are still available.

ISSN 0163-7916; ISBN 0-933286-22-8
Library of Congress Catalogue Card No. 80-70583
$9.95

LANDSCAPE: PERCEIVING THE LAND AS IMAGE

BY MARK JOHNSTONE

It is probably safe to assume that very few of us devote much thought to the land we live on. Those of us housed in cities can easily live through a day without setting foot on bare ground. We are trained to stay on the covered concrete paths and not trespass on those sacrosanct patches of grass that decorate our streets, front yards and parks. Yet many of us encounter images of the natural landscape daily. In pictures on our walls, in books and magazines, on television and billboards, the natural landscape appears recurringly as a symbol of an ideal.

By the time photographic technology could be rigorously utilized in the American landscape, the country's unpopulated wilderness lay west of the Mississippi. Each photographer ventured forth with knowledge of the civilized eastern landscape and was presented with a fresh set of visual problems. Through photographs the land was slowly cultivated, not in an orderly fashion, but in an erratic and tentative manner that often gave an indication of the respect demanded by the physical place because of its extreme

conditions. Often photography did not beat civilization to a particular place before the raw sense of the land had been buried by the marks of its human inhabitants. Today, much drama and variety remains in the landscape, chiefly preserved in the lands of the National and State Park systems. The significance of what has survived, however, not only as physical matter but as images, has shifted. A history of the medium can be traced in photographs of the land, but the issue becomes more complicated if the question is asked, "What meaning can be found in these pictures?" The photographs that have accumulated through the years describe not only attitudes about the land, but about how we view photographs.

The stories which historically accompany the making of photographs provide one context for those pictures. An understanding of the technical constraints under which the photographers produced the pictures supplies another. Both of these contexts can enlarge an appreciation of landscape photographs, yet they fail to penetrate the phenomenon of

the photograph itself, the essence of the image. Early Western photographers such as Timothy H. O'Sullivan, Carleton E. Watkins and William Henry Jackson, though using photography as a medium for reportage, had more than simple descriptive images emerge in their photographs. Like others of their era they sought relief and a sense of expansive regeneration in the aftermath of the Civil War. One can only imagine what seeing the Western landscape for the first time on the ground glass of their view cameras wrought on the topology of their minds.

Despite the fact they were charged with imparting specific kinds of information—a sense of scale, the fantastic landforms, a record of the places they passed through—the only consistent reference points in any and all of their photographs was that of the man behind the camera and his transient perception. How each view came to be assembled as a photograph became the constant. Unconsciously, though with a photographic awareness, mind and eye were inserted in the construction of photographs of the land.

Photography not only engaged the land, but art as well. The dual embrace provided ground for active debate on what form photographs should take, and how that should be achieved. In the late 1850's Henry Peach Robinson advocated that for photographs to be considered as art they should adopt pictorial strategies. Allegory was the tool, and painting models the framework, to which the medium was applied. His advice may have been misguided, but it did introduce an attitude that has survived until today: that the artist can and should control the medium in any way necessary. Peter Henry Emerson, who later became Robinson's foe in arguing the best interests of the medium, propounded a *naturalistic* doctrine for producing photographs. Emerson advocated the stance that, since the photograph was an impersonal document, it should be used as such to produce art. His ideas of direct and honest camera work were complicated by his accompanying explanatory theories. The distinction between those concerned with art and those concerned with photographs lay in the attitude of

the photographer towards subject matter. The early landscape photographers accompanied expeditions to produce information that was purely photographic, not artistic. These early landscape photographers were no doubt influenced by conventions of landscape painting, but evident in their work is an abandonment of pictorial standards as they preempted those for what could be best accomplished with their materials. They sought to establish standards for photography within the landscape.

The consideration of photography as an art was carried forward through the turn of the century. Members of the Photo-Secession readopted pictorial strategies in an attempt to signal artistic intent in the appearance of their images. Alfred Stieglitz, the organizer and chief spokesman for the group, though he ultimately turned from the means they adopted in his own work, endeavored not only to influence how photographers approached their work, but how the public viewed it. He proposed that photographs could engage both description and art, implying, but not defining or describing, certain distinctions. The photographs would use photography's informational capacity to render form, yet that form could be made metaphoric in the quality of its appearance. Stieglitz' well known photographs of clouds, while not of the physical landscape, elusively express that sense of "equivalency", the intertwining of form, subject and meaning. Minor White, in an adaptation of this idea, brought an attitude of spiritual introspection to the photograph. Forms in the landscape were imbued with a romantic sense of contemplation.

A different attitude can be found in the constructivist sense of abstraction that Imogen Cunningham produced in her many plantlife studies. Edward Weston's photographs possess a delineation of form and structure in a solid, sensuous manner. Ansel Adams, Brett Weston, Wynn Bullock, Paul Caponigro—in the work of each man we recognize qualities of transcendence, but like the artists previously mentioned, we do not fully understand how their attitudes operate in their photographs.

4

Tourism defined a picture-making attitude even before the materials and process of photography had been simplified for mass consumption. At the advent of the Kodak and the Model T Ford, the American public had already begun collecting forms of photography on a massive scale. If one had not the means to visit a place, stereographic views were purchased. Should you be able to travel by train, stage or horseback and play witness to the rugged grandeur of a natural scene, evidence of such experience was desired. The land was appropriated into picture parcels, souvenirs to be seized, triumphantly borne home and pasted on the trophy pages of the family album. The land was preserved in parks, and within them were signs indicating where one could make a gestural territorial assertion over its expanse. Who has not stopped at a "Picture Spot" because, grudgingly, it is the most scenic view? Indeed, the marriage of the land and photography runs deep enough to warrant a campground in southern Utah called Kodachrome Basin, a sign that as industrialization set into our urban centers the land suddenly became less wild.

It is an accepted fact that photography can render a description of virtually anything in the physical world. While the opportunities to make photographs have necessarily increased (simultaneously invoking the law of increased entropy: greater disorder), the subject categories have not commensurately changed in quantity. The land, given its own way, will not change quickly. Perceptibly, with shifts in weather and water conditions, plant growth flourishes or disappears over a period of years. A single photograph cannot show this. More noticeable over time are the marks of a rock slide or the rerouting of a stream bed. The radical extreme of immediate change can only infrequently be glimpsed in such awesome and humbling events as the eruption of Mt. St. Helens. Life reverberates throughout the landscape and the biological cycles of birth and decay, yet the land itself remains still.

Possibly it is this fact of stillness that invokes myths about the land. One hundred years ago the myth was the promise of unlimited expansion, riches in precious metals and other untold resources. When we view a landscape today we recall such dreams and hope to one day escape to a plot with a view beyond the smog. Yet, hard pessimism has crept in to coexist with that romantic nostalgia. We cannot deny the knowledge that is ours. Who would wish to retire to parts of Nevada's great expanses knowing that radioactive uranium tailings dust its winds?

In Eliot Porter's color photographs of Glen Canyon we encounter resplendent colors and a precise optical clarity. The photographs shimmer with a clinical perfection and are lit with a spread of light that often seems alien to nature. Here are details, often without an orienting sense of scale, of the natural landscape; and while the pictures are about form and color, they are also about Glen Canyon. Within these pictures is a veritable fairyworld of abstract color and shape that conforms to ideals of what modern art should look like. The photographs also raise an important point about conservation and land management, and the relation of our society to the land as a resource.

The appearance of this work indicates that we consider it art, and yet the way it is used can introduce other intentions and meanings. Compare this sense of place with descriptions of the land conveyed in the photographs made by satellites. Technical enhancement not only complicates the beauty of a view but presents an amazing array of information, from descriptions of geological substructures to the growth patterns of plant life. These are intended as informational views of the land, yet are Porter's photographs any more or less beautiful? The distinction, of course, lies in what may be gleaned from seeing a group of photographs produced by both sources. The way Porter chooses to make different images describes something about him, his ideas and attitudes. At most, a series of the satellite views will tell us something about the automatic mechanical abilities of the equipment employed, which indiscriminately describes any topology at which it is pointed. Technology alone has rarely produced interesting photographs, those descriptions of the

land serve to reinforce the intractibility of its nature.

It is safe to assume that crossing the land by horseback, and then by automobile, would develop vastly different impressions of the same places. The photographs Robert Frank made while criss-crossing the United States in 1955 are not expressly concerned with the land, but they do alter our sense of where we live and how we view photographs. As traveler and artist he acknowledged a descriptive ability in photography and used that for the creation of a series of photographs that were as important for what existed between them as for what they depicted, and how they did it.

Frank's photographs have the raw look of photography—grainy, contrasty, sometimes blurred—yet they do not use the intrigues of form or content found in other pictorial art forms. Unlike the photographs of Stieglitz or Weston, his photographs do not adopt conventions informing the audience that art is being viewed. Rather, it is a visual contention of the work that, simply enough, this is photography. In the late 1950's Frank's photographs served to dispel a myth about America while creating another in its place. His photographs are transitory in the sense that they are about change and about being on the edge of things and places. In *The Americans* Frank extended ideas about photography that Walker Evans had developed in his book *American Photographs.* What the viewer must come to grips with in both is the information which isn't there.

In art we are no longer dazzled by those who gather and indiscriminately collect; in the practice of photography such activity describes only the ease of the medium and nothing of the vision of the camera operator. To appraise the options open to the photographer one must acknowledge the simultaneous changes that occur, and that are unique to the act of photographing. One may start with where to place the camera. In confronting the land, details of geological structure as well as great expanses, the slightest shift in position will often cause virtually everything to change alignment in the photograph. It is this search for the correct position, in physical terms, in formal terms and in quality of content, that is the unending goal of all contemporary photographers of the landscape.

Through use of a negative format larger than 35mm, some photographers follow a long standing tradition in the medium to take advantage of fine detail and beautiful tonal separation. Being rooted to a tripod is accepted as part of the working method. In other instances the tripod has been replaced by the photographer's body. Adopting contemporary attitudes from performance and conceptual art, the act of photographing becomes a visceral, physical interaction between photographer and subject matter, a trial with all the accompanying visual disappointments and joys. Some photographers use an invariant motif in their picture making. Others concentrate on a particular subject or place as their pretext for working. What is revealed to them through the experience of photographing gives impetus to and reason for the activity.

Many times what the photographer seeks is insubstantial and elusive. The atmosphere, the feel of a place, must somehow be translated into photographic values. Resonant qualities can be invoked by a use of color; emotional harmony or dissonance can be dramatized. In work employing color applied to the print this can be judiciously and selectively controlled. Other workers accept the response of the materials as they are supplied by the manufacturer or understand how these may be subtly manipulated. It is the recognition of all these factors, that photography is not simply an either/or set of propositions but is filled with options, that describes something of the task to be faced every time a photographer approaches the land with a camera.

All photographs appear to engage a sense of rational order. This reasoning exists in the appearance of the rendered content. It is lenticular, conforms to perspective and seems congruent to the experience and sensation of sight. But beneath that which is manifestly made apparent is a latent content, one which is abstract, illusionary and imaginative. Consider the West, the subject of so many

landscape photographs. The West has been a repository for certain values over the years, a territory marked by physical, pictorial and imagistic travel. In novels, Hollywood film and television serials, a mythic image of the landscape has been created describing equally mythic people, time and events. The content of that myth joined with the sense of history as it did exist and became a model. That model, used in literature to develop a wealth of images, is often called to mind when we view photographs of the western landscape. Fable and fiction become as valid a reference point as the unusual landforms themselves, and the natural order which belonged to the land is ruptured and altered without being physically touched.

The paradox that dangles in front of our eyes is this. We can never take full or true advantage of what is promised in what we see, for when we do, we lose it. Photographer and viewer respond not to the landscape itself but to concepts of it. The land has become a symbol absorbed by our culture and has assumed a psychic as well as physical reality. The symbol became a multi-faceted view with no single meaning. It is the experience of photographs of the land that molds our perception of it. In discovering what these pictures mean as perceptive patterns of the world, it is possible to learn something of photography.

Mark Johnstone is a critic, teacher and photographer living and working in the Los Angeles area. His critical articles and reviews have appeared in publications such as Afterimage, Artweek, Camera *and* Exposure.

GAIL SKOFF

Gail Skoff was born in 1949. She received both her Bachelor (1972) and Master of Fine Arts (1979) degrees in photography from the San Francisco Art Institute. Among one-person exhibitions of her work are shows at the American Cultural Center, Paris (1977); Washington State University, Pullman (1978); and the Simon Lowinsky Gallery, San Francisco (1980). Her recent group exhibitions include the *1980 SECA Invitational,* San Francisco Museum of Modern Art; *Attitudes: Photography in the 1970's,* Santa Barbara Museum of Art (1979); *Color in Question,* the Catskill Center for Photography, Woodstock, New York (1979); and *Large Spaces in Small Places,* Crocker Art Museum, Sacramento (1980). Her photographs have been published in *Artforum, Picture Magazine, Aperture* and *Camera.* Among the public collections that include her work are the Bibliotheque Nationale, Paris; the Center for Creative Photography, Tucson; and the Oakland Museum. Skoff received a National Endowment for the Arts Photographer's Fellowship in 1976.

Gail Skoff has consistently searched for subjects and situations that could be transformed through her illusory images. In her early photographs she placed people and props in particular locations to create strange, exotic environments. On a trip to Hawaii several years ago she made some landscapes and was surprised to find that these provided the same displacement of space. She consciously began to look for uninhabited landscapes and, during her first trip to the Southwest in 1978, found the open spaces there to be just the vehicle she needed.

The flatness of the foreground produces a sense of two-dimensional space in her photographs, creating a feeling of openness and a suspension of time similar to that she had originally experienced at each location. This unreal sense is accentuated by her use of hand-applied color. She has developed a process that, unlike traditional color photography, gives her a control over specific colors and tones that she feels is important. The photograph is the raw material; the completed image evolves after many hours of working with possible color combinations.

Mastering these materials has brought Skoff extremely close to the process of her work. She has recently discovered that the emptiness of the landscape does not, by itself, provide enough complexity. Her interest in the forms of the Western landscape is growing and she has been increasingly drawn to such areas as New Mexico's White Sands National Monument and Wyoming's Yellowstone National Park. Where the land was previously a perceptual vehicle, it now borders on being the actual subject of her photographs.

Mary Virginia Swanson

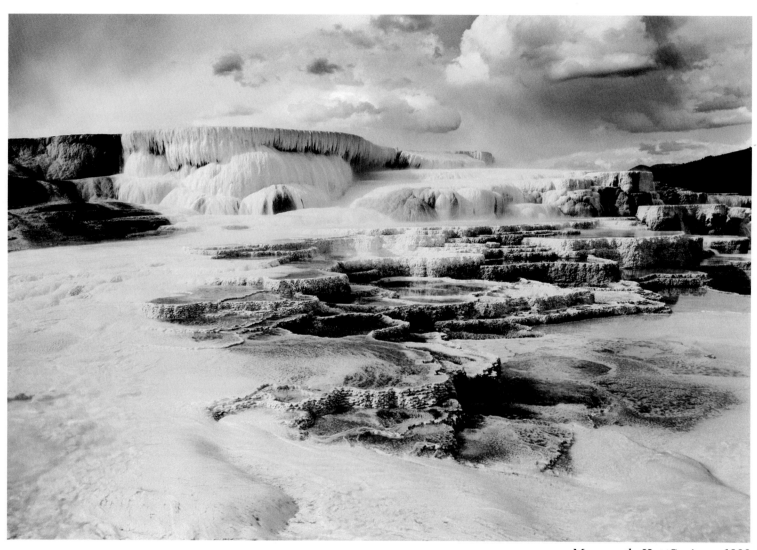

9

Mammoth Hot Springs, 1980

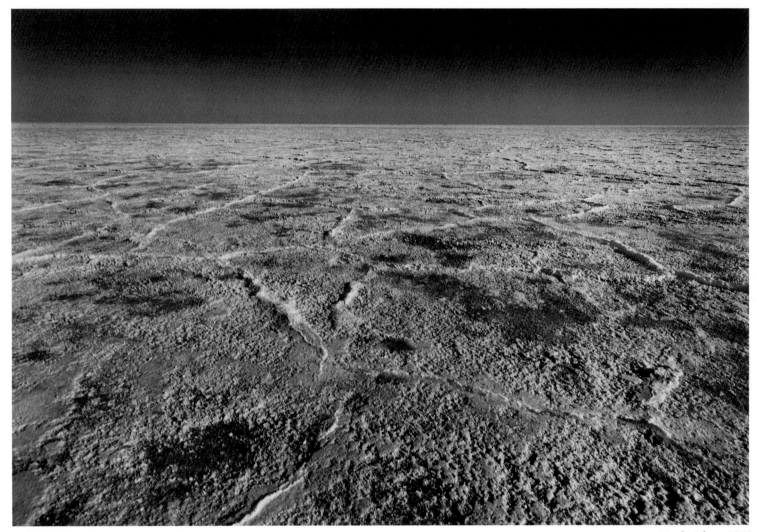

Utah Flat, 1979

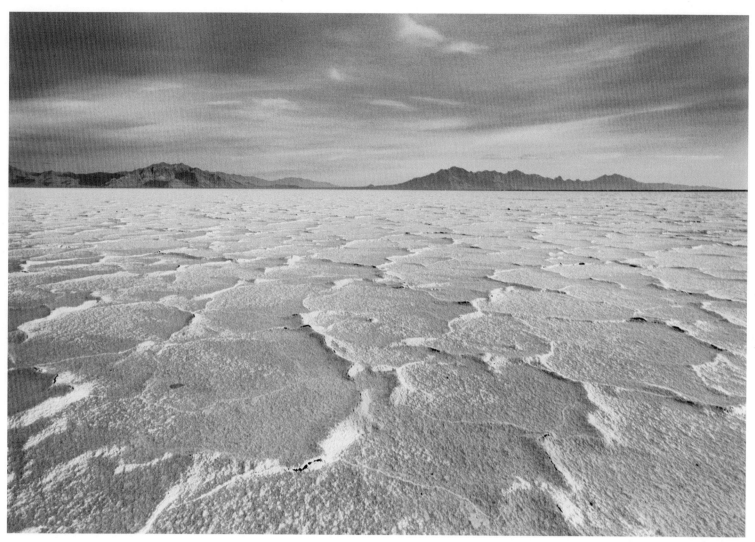

Sunrise, Utah, 1979

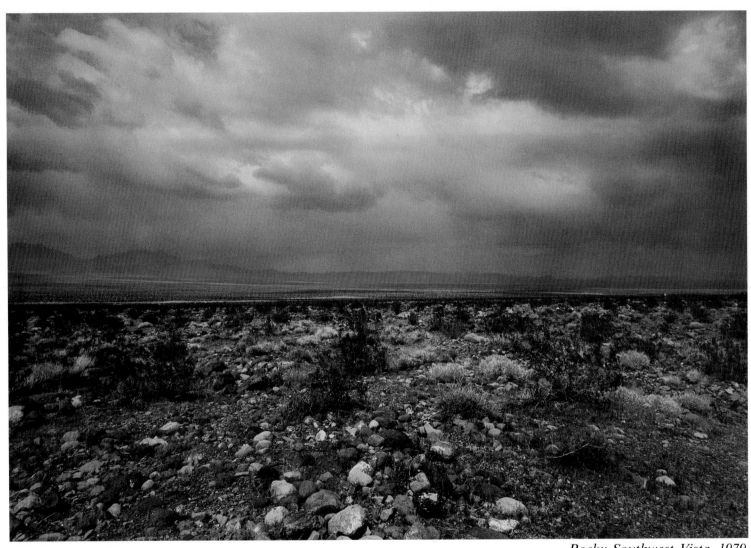

Rocky Southwest Vista, 1979

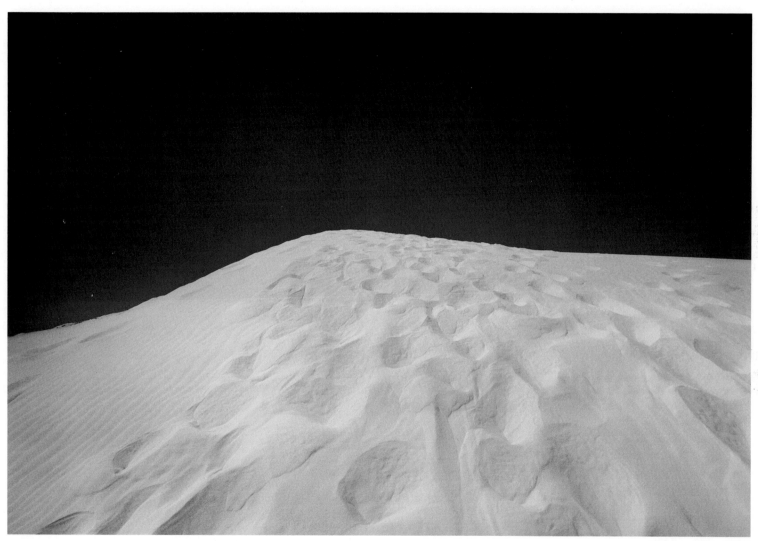

13

White Hill, 1980

LYNN LOWN

Lynn Lown was born in 1947. He received his BFA degree in photography and printmaking from the University of Iowa in 1971 and his MFA in photography from the University of Oregon in 1973. One-person exhibitions of his work have been presented at the Armory for the Arts, Santa Fe (1979); the Pittsburgh Filmmakers Gallery, Pittsburgh (1980); and Texas Christian University, Forth Worth (1980). His work has been a part of a large number of group exhibitions, including shows at the Sheldon Memorial Art Gallery, Lincoln (1977), the Dallas Museum of Fine Arts (1978) and the University of New Mexico, Albuquerque (1979). Among the public collections that include Lown's work are the Museum of Fine Arts, Albuquerque; the University of Iowa Museum of Art, Iowa City; and the Center for Creative Photography, Tucson. Lown is currently on the faculty of Texas Christian University, developing an undergraduate program in photography.

The landscape photographs reproduced here, taken in the La Mesa burn area of New Mexico's Jemez Mountains, can be compared to the pen and ink gesture drawings of Oriental Art. Lown was exposed to Eastern philosophies at an early age and his understanding of Asian art, as well as his concurrent activity in photography, printmaking and painting, have influenced his personal creative work. The landscape has been a constant photographic theme for the past ten years. He has worked with many cameras throughout this period, but now prefers using a medium format camera. He feels that the topography of the Southwest lends itself to his "telephoto" vision, and that this is most accurately rendered in the square.

As is apparent in the richness of these photographs, Lown has a passion for creating the most beautiful print possible. He enjoys the printmaking qualities of the photographic process, its multiplicity and its democratic sense. The final object is the most important part of his process and he admits to being seduced by the surface of paper itself.

The geometric patterns he creates within the frame provide a more formal view of his subject, rather than present photographic clues that lead to a knowledge of its geographic location. This structuralism avoids imparting information that would furnish an understanding of the reality of these lifeless hillsides. The prints have a strong reference to calligraphy, to printmaking and to dry point etching, all three of these inherently graphic. By utilizing qualities of these essentially non-photographic media Lown established in his photographs a rich appreciation for the spontaneous nature of line and form.

Mary Virginia Swanson

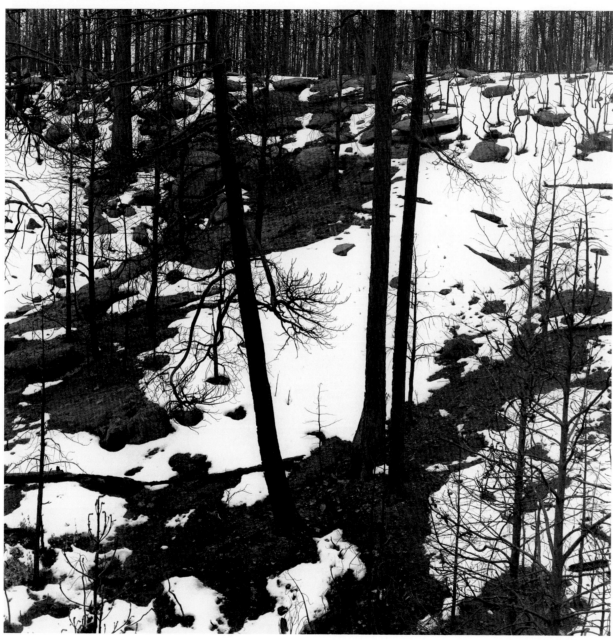

15

Untitled, 1978

16

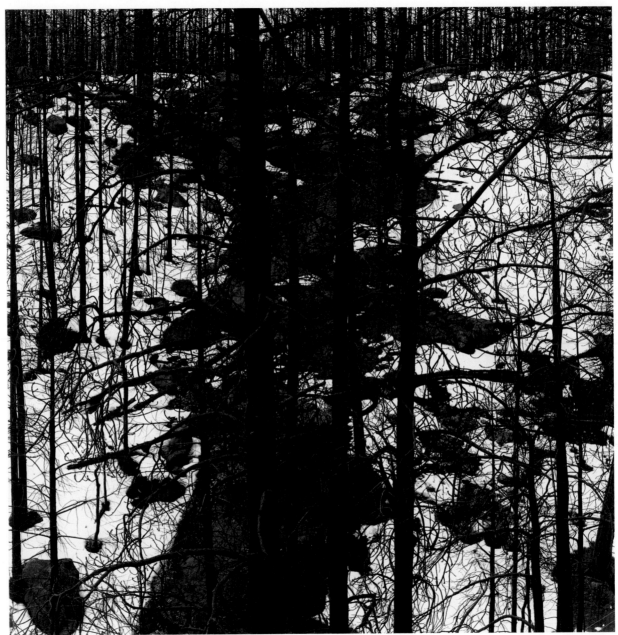

Untitled, 1978

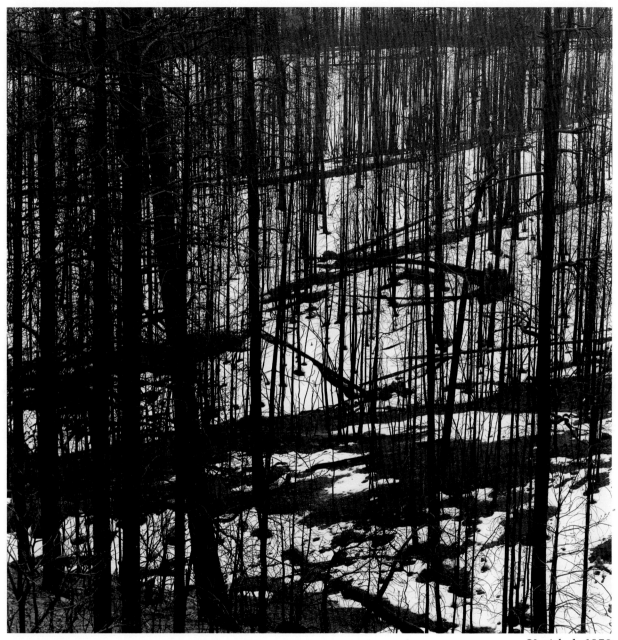

Untitled, 1978

18

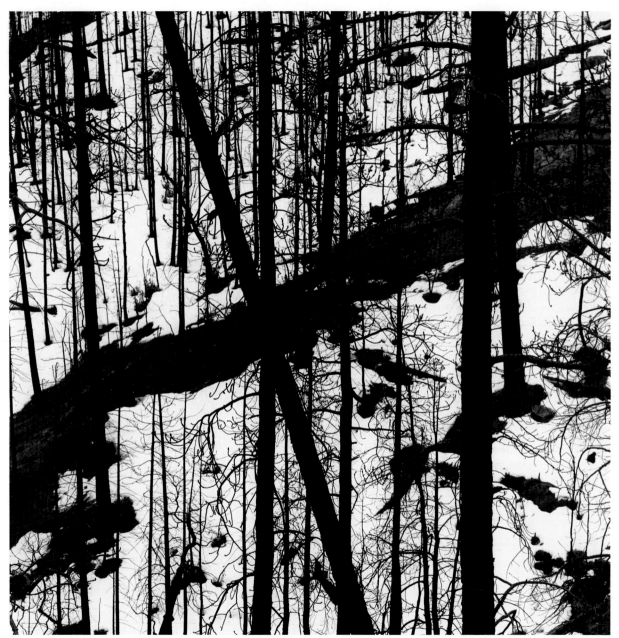

Untitled, 1978

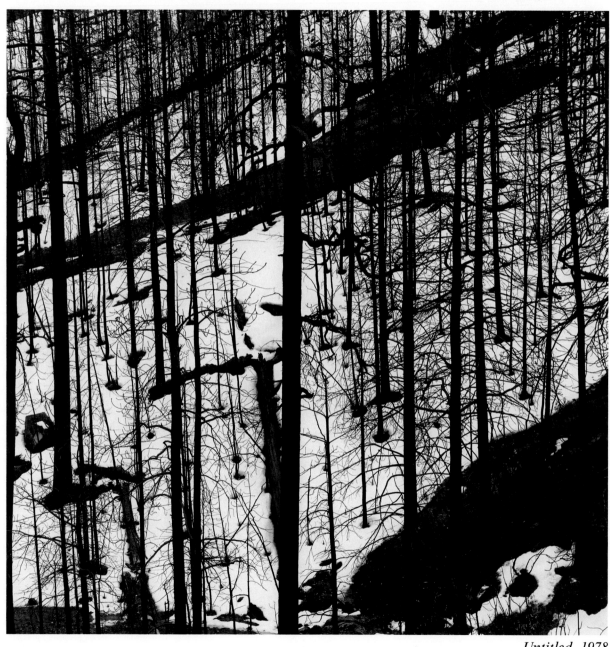

Untitled, 1978

LINDA CONNOR

Linda Connor received her bachelor's degree from the Rhode Island School of Design in 1967 and her master's degree from Chicago's Institute of Design in 1969. Since that year she has taught photography at the San Francisco Art Institute and has participated in workshop programs throughout the country, including several at The Friends of Photography and at the Apeiron Workshops in Millerton, New York. She was recipient of a Photographer's Fellowship from the National Endowment for the Arts in 1976; in 1979 she received a Guggenheim Fellowship that allowed her to travel and photograph in Indonesia, Southeast Asia, India and Nepal.

Among Connor's many one-woman shows are exhibitions at San Francisco's de Young Memorial Museum (1977), the Los Angeles Institute of Contemporary Art (1979) and Light Gallery in New York City (1980). Her photographs have been included in many major group exhibitions, including *The Great West: Real/Ideal* at the University of Colorado, Boulder (1977), *Mirrors and Windows* at the Museum of Modern Art (1978) and *Aspects of the '70s* at the DeCordova Museum, Lincoln, Massachusetts (1980). Her photographs are included in many public collections, including those of the Boston Museum of Fine Arts, the Museum of Modern Art and the National Gallery of Canada, Ottawa.

In 1979 Connor published *Solos,* a book of photographs made with a 75-year-old Century 8 by 10-inch view camera equipped with a "semi-achromatic" soft-focus lens. While completing her work on *Solos,* Connor photographed with a fully-corrected lens providing the sharp detail normally associated with view camera photography. Although she has explored a variety of subject matter, the landscape, particularly the forested areas of New England, has been a major theme within her recent work.

Eschewing the grandeur and expansiveness typical of the Western landscape, Connor has concentrated on dense forest land, photographing in autumn and winter to accentuate the linear structure of the trees rather than their leafy summer masses. Composing carefully on the ground glass of her view camera, Connor establishes in her photographs a visual order from the chaos of the forest. The optical compression of three-dimensional space between trunks and branches within the frame creates new shapes where areas of similar tonalities intersect within the print.

Connor's concerns are not strictly formalist, however; she is as interested in the meanings of the forms as in their graphic reality. She is fascinated by the way certain structures, corkscrew-like forms for example, recur within a body of her photographs. This recurrence is not the result of a conscious search for similar structures, but an expression of an archetypal response to the landscape. The random nature of the forest is clearly important to these photographs, yet the ultimate meaning of the images is derived from Connor's photographic presentation of a specific, carefully composed arrangement of forms.

David Featherstone

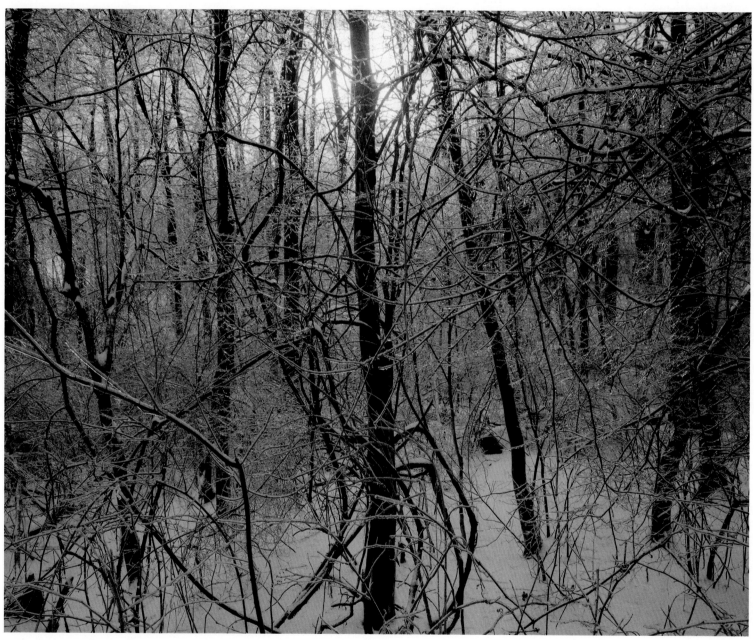

Ice Storm, Connecticut, 1977

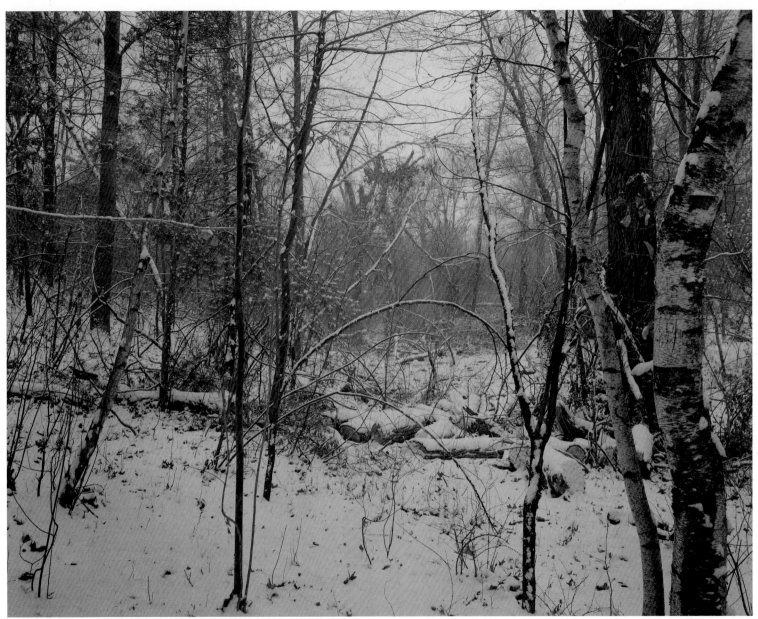

Belmont, Massachusetts, 1978

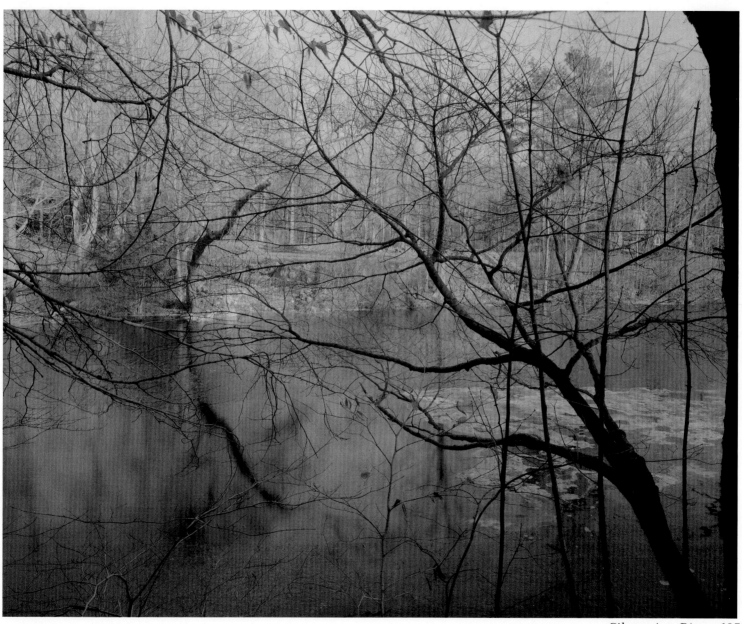

Silvermine River, 1978

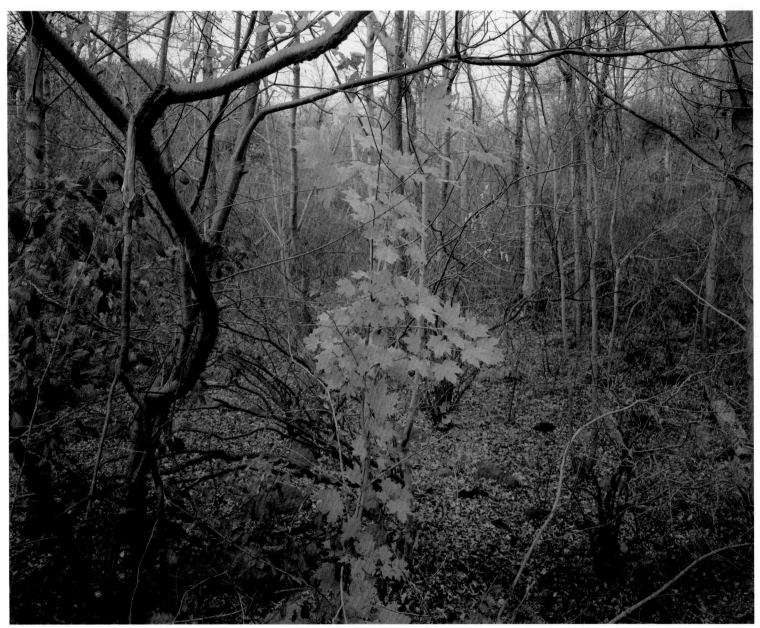

Belmont, Massachusetts, 1978

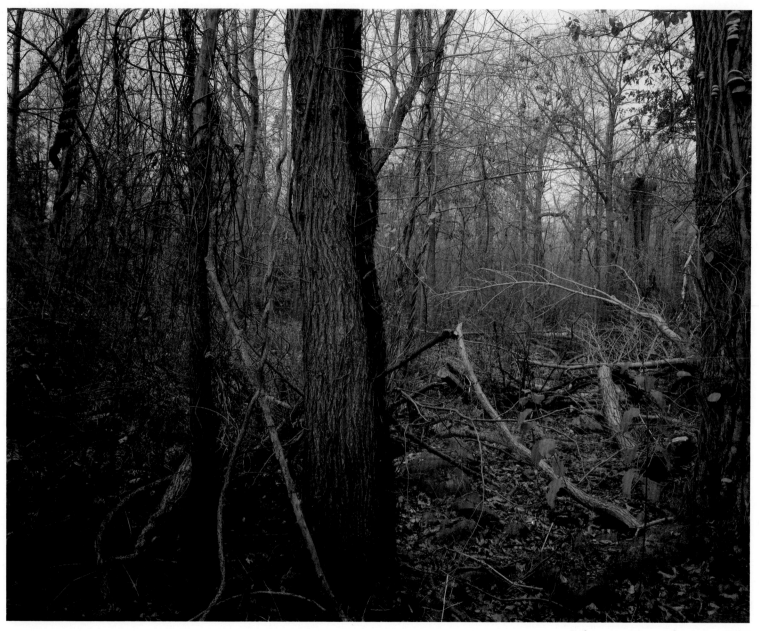

25

Belmont, Massachusetts, 1978

ROBERT ADAMS

Robert Adams was born in Orange, New Jersey, on May 8, 1937. His childhood was spent in a series of westward migrations, from New Jersey to Madison, Wisconsin; to Denver for high school and on to California for college. Adams received his bachelor's degree from the University of Redlands and a Ph.D. from the University of Southern California. From 1962 to 1970 he taught English at Colorado College in Colorado Springs. He has been an independent photographer and writer since that time.

Adams has received many awards for his work in photography, including National Endowment for the Arts Photographer's Fellowships in 1973 and 1978 and Fellowships from the John Simon Guggenheim Memorial Foundation in 1973 and 1980. He has had solo exhibitions at galleries such as the Colorado Springs Fine Arts Center (1971), Castelli Graphics, New York (1976), the Sheldon Memorial Art Gallery, Lincoln (1977), The Denver Art Museum (1978) and The Museum of Modern Art (1979). Among his many group exhibitions are *14 American Photographers,* Baltimore Museum of Art (1975), *New Topographics,* George Eastman House, Rochester (1975), *The Great West: Real/Ideal,* University of Colorado Boulder (1977), *Mirrors and Windows,* Museum of Modern Art (1978), and *American Images,* Corcoran Gallery, Washington (1979).

Adams' photographs are part of many public collections, including the Metropolitan Museum of Art, George Eastman House, The Houston Museum of Fine Arts and the Australian National Gallery.

It was his third book, *The New West* (1974), that brought Adams to national attention as a photographer. In the introduction to that volume John Szarkowski stated, "Adams' pictures are so civilized, temperate and exact, eschewing hyperbole, theatrical gestures, moral postures and expressive effects generally, that some viewers might find them dull." Many did find them dull or unintelligible, as is often the situation when an artist attempts to break new ground. His next book, *Denver* (1977), continued his development of an urban landscape sensibility in which man as an obvious participant.

Adams was a central character in the cast of a mid-1970's exhibition titled *New Topographics—Photographs of a Man Altered Landscape.* It showed that Adams was not working alone but that his work could, in fact, be seen as part of a movement towards a reconsideration of what is important in a photograph. The landscape is no longer grand. Man's trappings have interceeded; traditional composition is no longer important since form equals content. In Adams' recent work, published in *Prairie* (1979), and *From The Missouri West* (1980), he displays a stronger interest in rural as opposed to urban settings. While he is still concerned with man's relationship to the environment, the pictures seem less an indictment, perhaps because urban man's impact is less obviously the subject.

This selection of Adams' landscape photographs deals not with obvious important natural phenomena, but with subtle areas and changes in the land. Each contains traces of man's impact on nature and forces us to realize that, while the less obvious part of the world may in fact be beautiful, the future is uncertain and fragile at best.

James Alinder

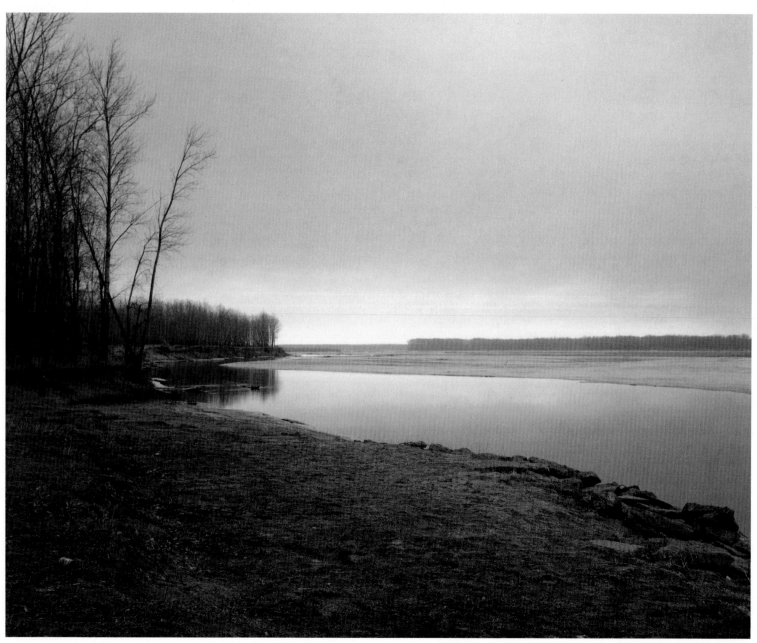

Missouri River, Clay County, South Dakota, 1977

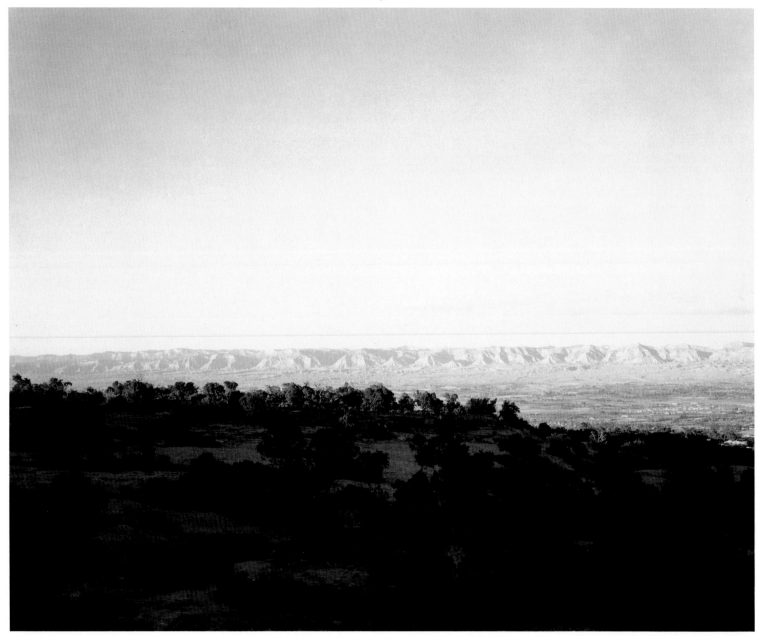

Mesa County, Colorado, 1978

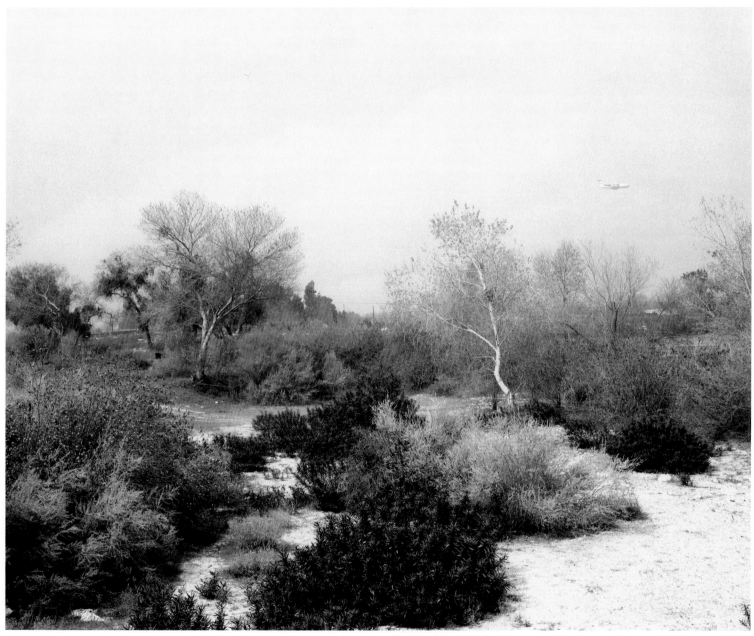

Santa Ana Wash, Norton Air Force Base, California, 1978

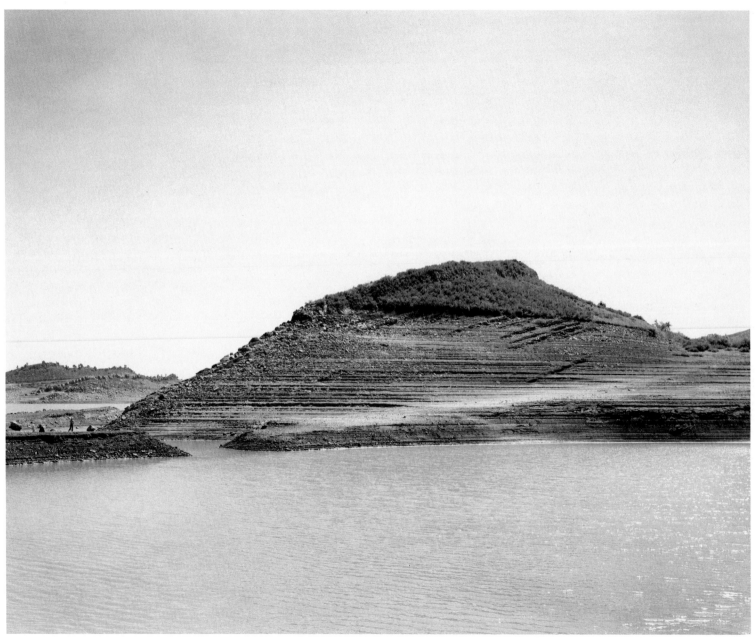

Horsetooth Reservoir, Larimer County, Colorado, 1977

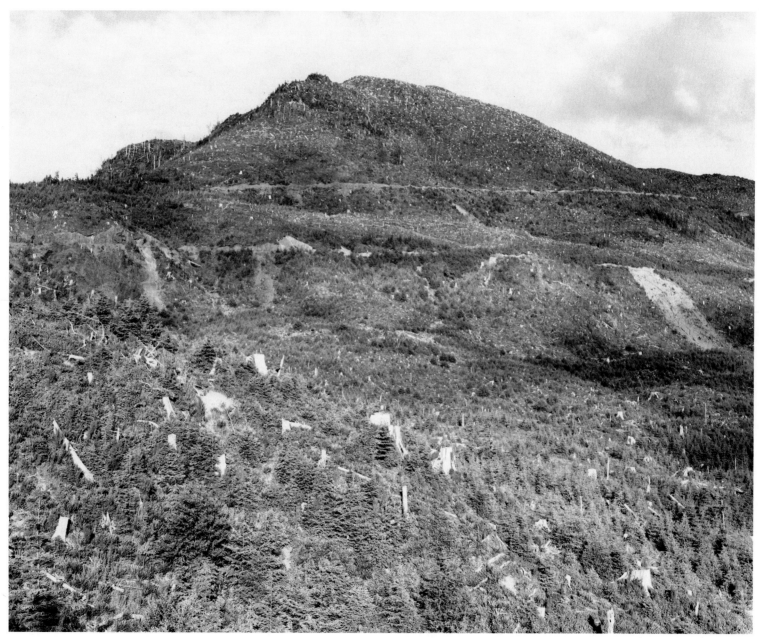

Clearcut and Burned, East of Arch Cape, Oregon, 1976

WANDA HAMMERBECK

Wanda Hammerbeck was born in 1945. She received her Bachelor's and Master's degrees from the University of North Carolina, Chapel Hill, in 1967 and 1973, and her Master of Fine Arts degree from the San Francisco Art Institute in 1972. Her work has been shown in solo exhibitions at the O. K. Harris Gallery, New York City (1979); Orange Coast College (1978); and the San Francisco Museum of Modern Art (1978). Among the group exhibitions that have included her work are *Attitudes: Photography in the 1970's,* Santa Barbara Museum of Art (1979); *The Image Considered,* Visual Studies Workshop (1979); and *Photography: Recent Directions,* DeCordova Museum, Lincoln, Massachusetts (1980).

Hammerbeck's photographs are included in many public collections, among them the Center for Creative Photography, Tucson, Arizona; the Fogg Museum of Harvard University, the Australian National Gallery, the California Museum of Photography, Riverside, and the Museum of Modern Art. She received National Endowment for the Arts Photographer's Fellowships in 1979 and 1980. She is currently an instructor of photography at Holy Names College in Oakland, California.

The common denominator of all Hammerbeck's photography has been the landscape. This was expressed first in a more conceptual framework in her 1978 book, *Depositions,* and in her 1979 project, *Reproductions of Reproductions.*

During this period she also traveled throughout the United States, in the vast expanses between the Rocky Mountains and the Coastal Range as well as in Hawaii and the deep South, where the photographs here were taken. She is entranced by the fact that our minds delete the foreground elements from our field of vision when focusing on distant points; in her photographs she includes the entire barrage of elements within the frame.

It is this interest in the push-pull of forms, in the tension between the foreground and background, that is the key to her work. The photographs present a direct confrontation with form, an attention to specific detail and an organization of space in which all parts are equal. Her lush use of color, approached in a realistic manner, guides us through the frame by drawing our attention to the smallest elements visible among the foreground foliage. We discover that these shapes and colors are echoed throughout the frame. In her finely crafted photographs Hammerbeck balances highly emotive subject matter—the integrity of the vegetation—with formal composition. The resulting images imply an incredible order and provide for her a meditative sensibility, a place for concentration and for consideration of detail. This body of work is more overtly romantic than anything she has ever done.

Mary Virginia Swanson

Untitled, 1980

Untitled, 1980

Untitled, 1980

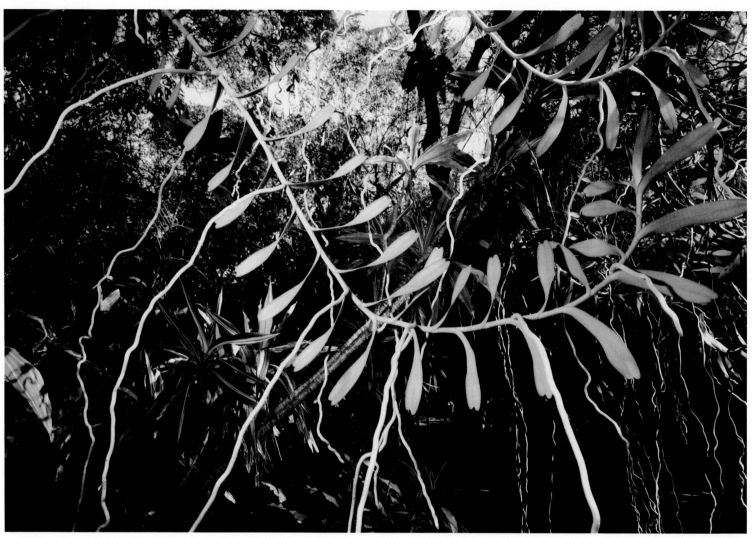

Untitled, 1980

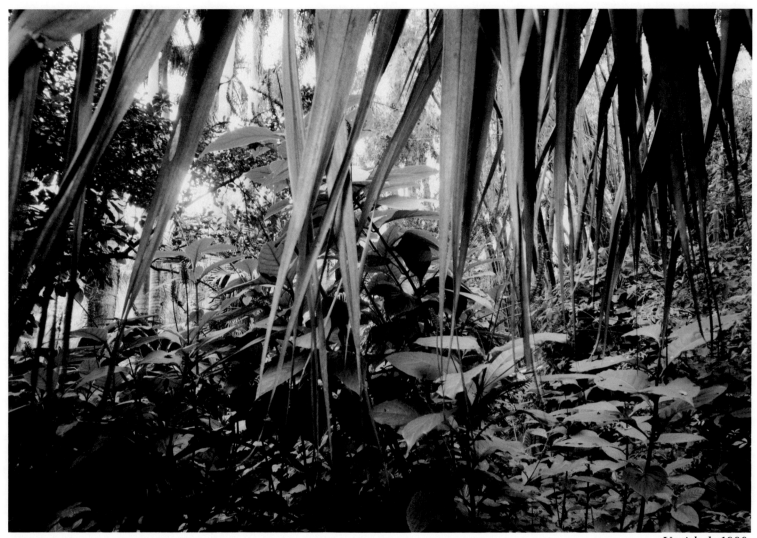

Untitled, 1980

JAY DUSARD

Born in 1937 in St. Louis, Jay Dusard first visited the Southwest in 1960, traveling on an architectural study scholarship from the University of Florida, from which he graduated with a Bachelor of Architecture degree in 1961. Although he was not deeply involved with photography at this point in his life he had seen photographs by Aaron Siskind, Edward Weston and Ansel Adams. On his trip to the Southwest he was strongly affected by the landforms there and immediately recognized in them subject matter for photographs. He knew he would have to return, but when he was able to do so three years later the duties of his job herding cattle, branding calves and guiding hunters on Arizona's John Slaughter Ranch kept him from actually making photographic records of the images he was seeing around him every day. He took a graphic arts job at Northland Press in Flagstaff and began to pursue his photography more directly.

From 1968 to 1974 Dusard taught photography with Frederick Sommer at the now-defunct Prescott College in Prescott, Arizona, where he still lives and works. Dusard has exhibited his photographs in galleries throughout the country, including those at the University of Delaware, Newark (1973); the University of Oregon, Eugene; Creighton University and Arizona State University, Tempe (all 1974). He has also taught at many photography workshops in the Southwest.

Dusard's photographs reveal the intensity of his eighteen-year involvement with the land of the Southwest, one that has led him to experiment with 11 by 14-inch and 12 by 20-inch cameras as well as the 8 by 10-inch camera used for the photographs reproduced here. Through his prints Dusard comments on the personally leveling power of scale in the desert. He is not interested in presenting photographs of buttes and cliffs and juniper trees, but utilizes these objects as abstract forms to express both the intimacy and openness of the Southwest. He sees the forms of the Southwest landscape as sculptural and manipulates them on the camera's ground glass in an almost plastic way. Through a considered distortion of real space, the towering height of massive rocks walls is revealed by the scale of a full-grown tree at its base; the expanse of eroded land by the faint view of a town in the distance. By filtering the camera's exposure he records green foliage and red-brown rock as nearly the same density on the negative and forces viewers to discover for themselves the hard/soft textures of the landscape.

The concern for visual ambiguity in both form and texture is central to Dusard's photographic vision. His commitment to the medium is carried through in his precision in the darkroom, where he strives to produce the one perfectly balanced printing of any particular negative. He has evolved a blend of visualization and technique that allows him to create and expand upon the photographic potential of the Southwest he recognized in the early 1960's.

David Featherstone

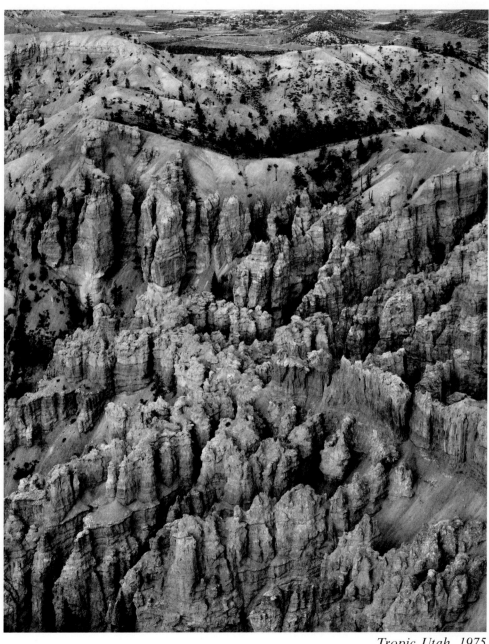

Tropic Utah, 1975

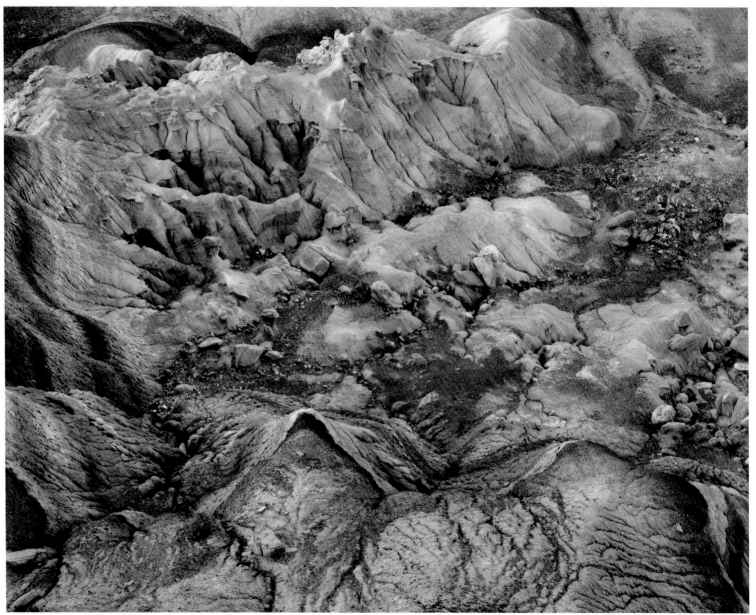

Blue Mesa, Arizona, 1977

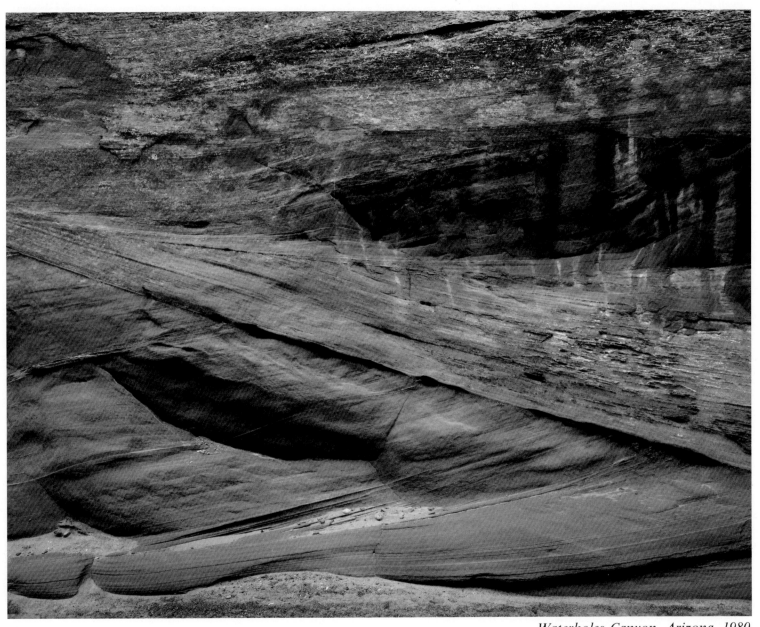

41

Waterholes Canyon, Arizona, 1980

42

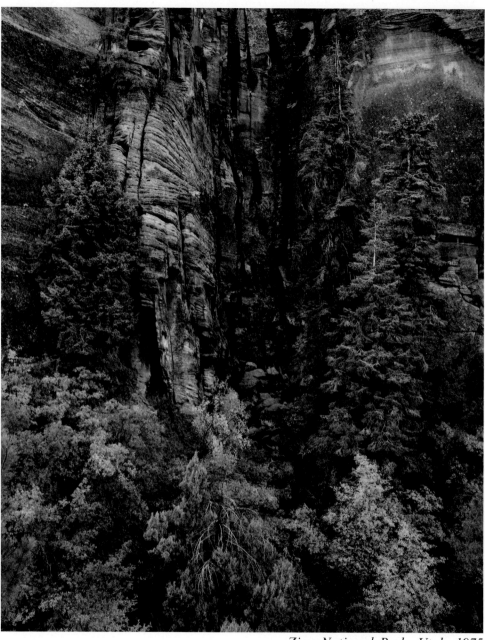

Zion National Park, Utah, 1975

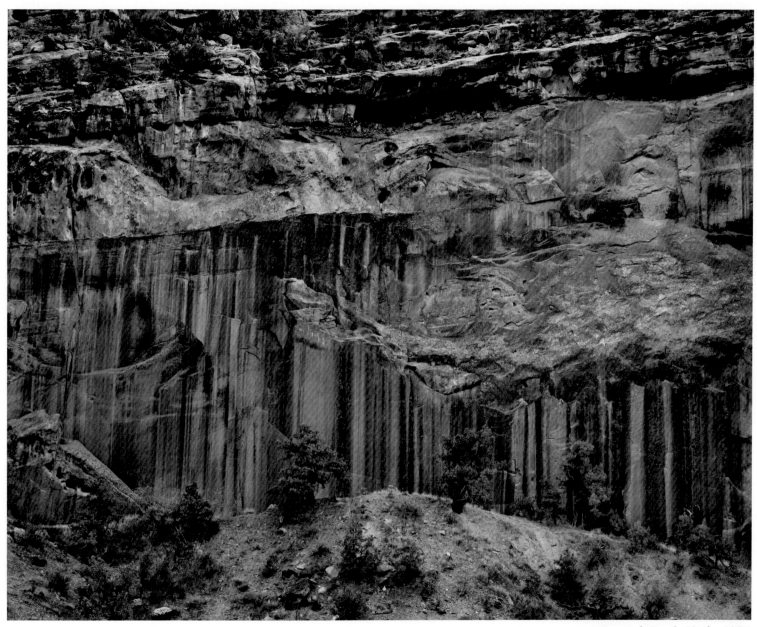

Capitol Reef, Utah, 1976

LAURA VOLKERDING

Laura Volkerding was born in Louisville, Kentucky, in 1939. She received her bachelor's degree from the University of Louisville in 1961 and her master's degree from Chicago's Institute of Design in 1964.

She taught at Rosary College in Chicago from 1966 until 1970, then joined the faculty of the University of Chicago, where she taught photography in the Department of Art. In 1980 she became head of the photography program in the Art Department at Stanford University.

Volkerding was a photographer with the Seagrams Bicentennial Project that resulted in the book *Courthouse.* Her group exhibitions include *The Edge of Photography,* Lightfall Gallery, Evanston, Illinois (1973); *Panoramic Photography,* New York University (1977); and *70's Wide View,* Northwestern University (1978). Her solo exhibitions include showings at the Fogg Museum at Harvard University (1977) and at the Dobrick Gallery (1976) and Renaissance Society Gallery (1979), both in Chicago. Her photographs are in many public collections, including the Library of Congress, the Art Institute of Chicago, the Smithsonian Institute and the art galleries at the Universities of Colorado, North Dakota, Nebraska and Nevada. While the landscape aspect of her work is considered here, her work-in-progress includes *Yes, Lord!,* a photographic study of the black church in American culture, and *China,* a document of the daily life in the People's Republic of China.

Volkerding's landscape photographs reproduced in this book were all made with a Widelux camera, a 35mm swinging-lens panoramic camera that covers at 140° field of view, more than three times the 45° field covered by a normal camera lens. The great wide-angle advantage of a 140° panoramic is also its limitation since few subjects exist in that dramatic proportion. The panoramic camera is thus one of the most difficult to use, but when utilized effectively it can produce images of exceptional excitement.

The land obliges Volkerding's extraordinary use of active line and intricate texture, its shape complies with the long, thin dimensions of her panoramic views. The landscape bends and flows in sympathy with the camera's natural distortion. Her beautiful understanding of positive and negative space create rhythmic and elegant areas of tonality, yet the photograph works as a whole.

In Volkerding's photographs the vast sweep of panoramic space is carefully controlled. These pictures are not vistas of the horizon at infinity, but are closer, more intimate views of regular places made into important spaces by her singular panoramic vision.

James Alinder

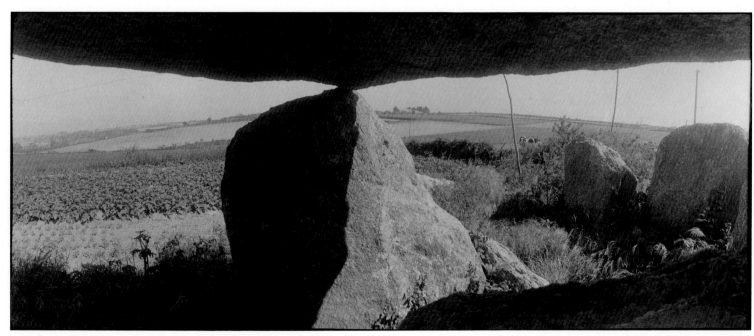

Potato Fields and Dolmen, Brittany, 1977

46

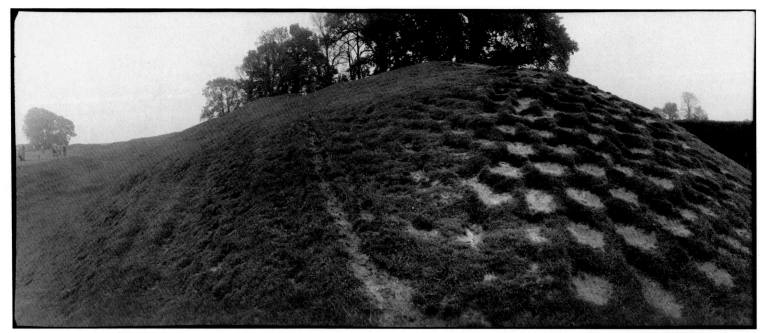

Cowpath at Avebury, 1977

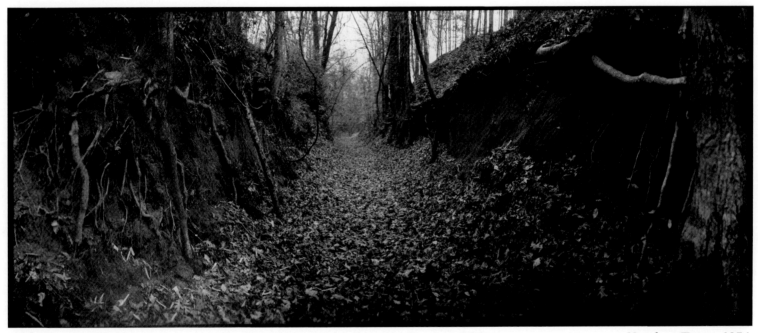

47

Natchez Trace, 1974

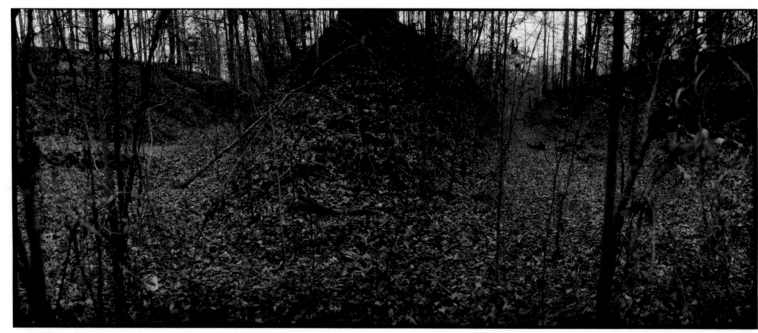

Natchez Trace, 1976

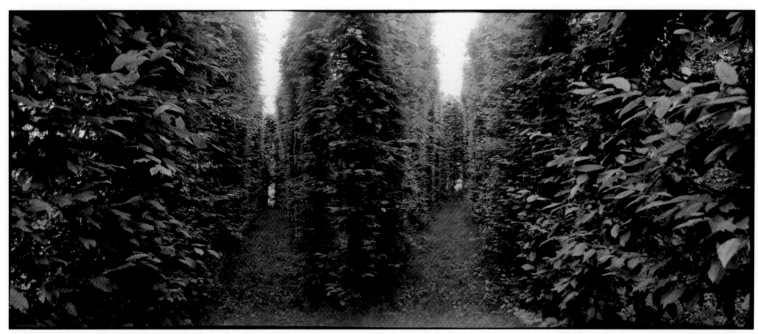

Maze at Villandry, France, 1977

ERIC JOHNSON

Born in Portland, Oregon, in 1949, Eric Johnson received his BA degree from the University of Oregon, Eugene, in 1971. He received both MA (1975) and MFA (1978) degrees in photography from the University of New Mexico. He has taught at Western Washington University in Bellingham and at Ohio State University in Columbus; he is currently on the photography faculty of the California Polytechnic State University in San Luis Obispo.

Johnson's photographs have been exhibited in one-person shows at the University of California Extension, San Francisco (1978); Camera Obscura Gallery, Stockholm, Sweden (1979); and The Foundry Gallery, Washington, D.C. (1980). Among the group exhibitions that have included his work are *New Photographics/1978* at Central Washington University, Ellensburg, and *New American Image* at the Galleria Del Cavallino, Venice, Italy (1979). His photographs are in a number of public collections, including the Bibliotheque Nationale, Paris; the San Francisco Museum of Modern Art and the University of New Mexico Museum of Art.

A former golfer, the emptiness and perfection of golf courses was a natural subject for Johnson's camera. The photographs reproduced here are from a series completed in 1977 and 1978 entitled *Ground Management (Golf)*. He was influenced in this work first by the photographic documents of earthwork sculpture, but more importantly by the imagery returned to the Earth from NASA lander-probes of Mars and the Moon. With their high horizons and elevated vantage points, the golf course photographs display the same concern for the information value of surface texture as do the NASA pictures.

The *Ground Management* images are not dispassionate, however. Although abstract, they deal with a feature of the environment familiar to all. They explore the nature of edges, the transitions between two sections of fairway or green where the grass has been carefully cut to different lengths. They also present the golf course in a more cultural sense as the edge between human construction and the land itself, as a metaphor for wilderness in an urban environment. Indeed, golf may be a game with a relatively small number of participants in terms of the land it requires, but in heavily populated areas its playing field is often the only open space where the shape of the land is left intact. The golf course itself is not an earthwork, but it is made to appear so in Johnson's photographs.

Like the lunar-lander pictures, these images require visual interpretation. The viewer must determine what expanse of space is actually being presented. Johnson uses a lens with a wide angle of view, yet the objects near the edges of the frame do not show the optical distortion one would expect from such a lens; the foreground does not appear out of proportion to the scale of the background. The non-specific shapes of the greens and fairways react to the optical properties of the lens by creating newly discovered space that exists only in its photographed form.

David Featherstone

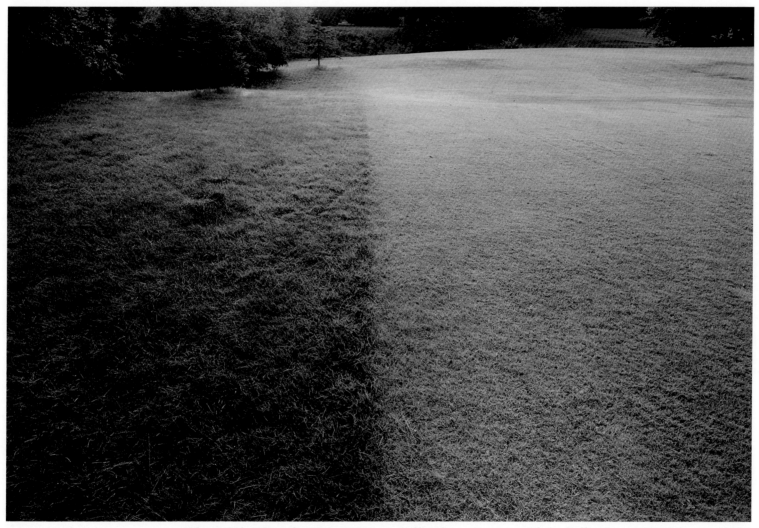

Edge of the Rough, 10th Fairway, Bellingham Country Club, Bellingham, Washington, 1977

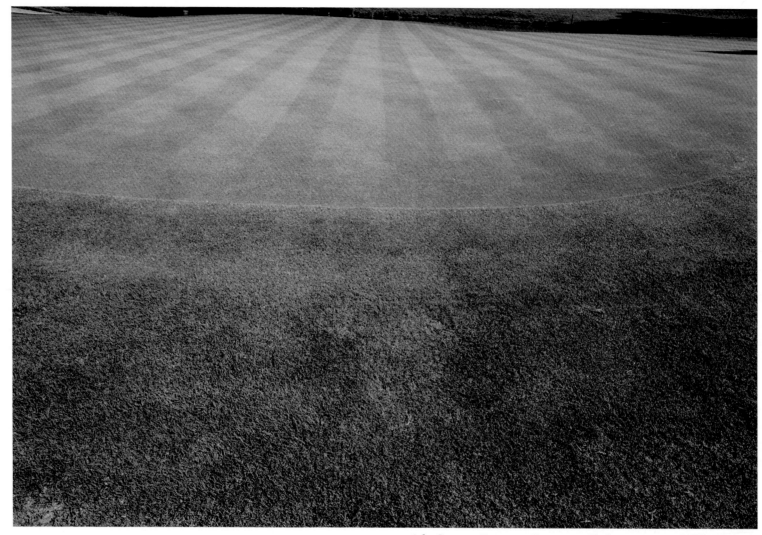

6th Green, Eugene Country Club, Eugene, Oregon, 1978

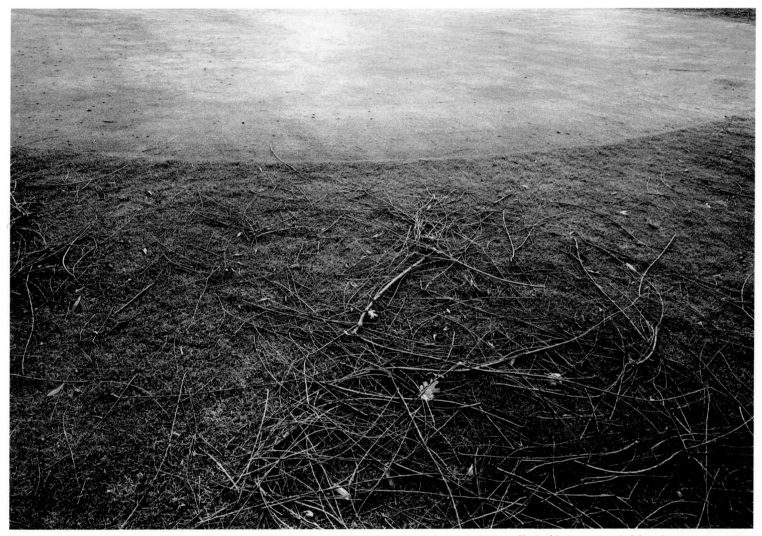

7th Green with Fallen Branches, Oak Knoll Golf Course, Ashland, Oregon, 1978

54

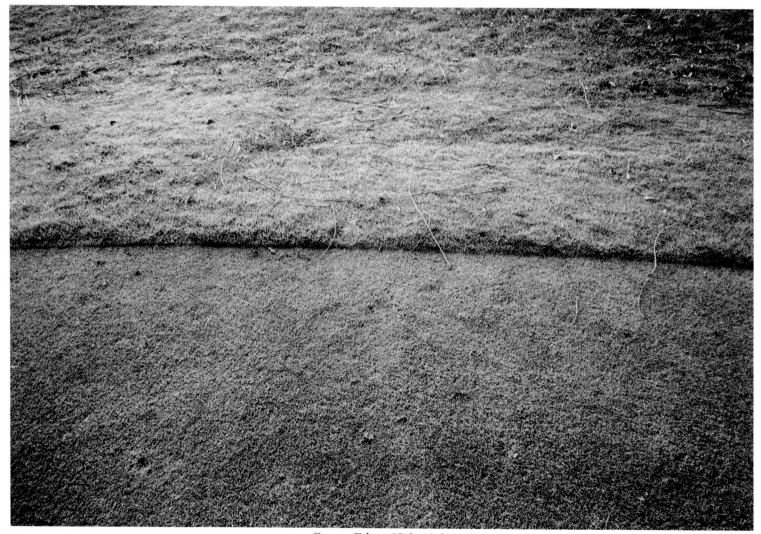

Green Edge, 17th Hole, Oak Knoll Golf Course, Ashland, Oregon, 1978

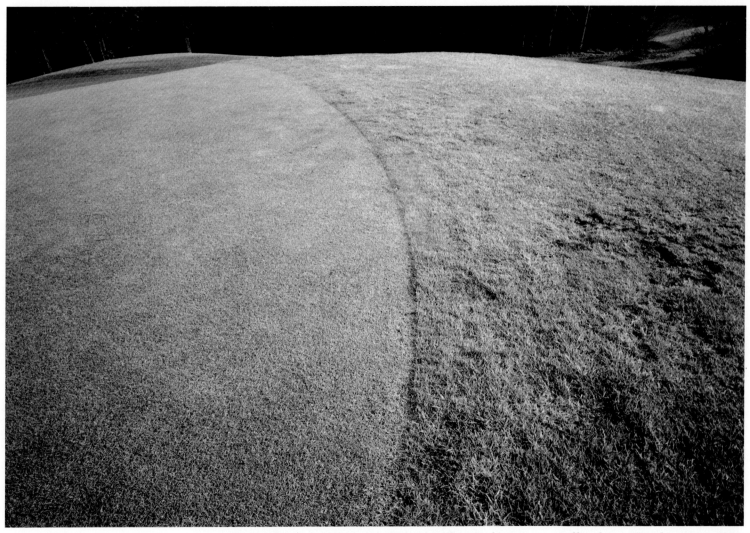

Green Edge with Mound, Lake Padden Golf Course, Bellingham, Washington, 1977

55

THE FRIENDS OF
PHOTOGRAPHY

The Friends of Photography, founded in 1967, is a not-for-profit membership organization with headquarters in Carmel, California. The Friends actively supports and encourages creative photography through wide-ranging programs in publications, grants and awards to photographers, exhibitions, workshops, lectures and critical inquiry. The publications of The Friends, the primary benefit received by members of the organization, emphasize contemporary photography yet are also concerned with the criticism and history of the medium. They include a monthly newsletter, a quarterly journal and major photographic monographs. Membership is open to everyone. To receive an informational membership brochure write to the Membership Director, The Friends of Photography, Post Office Box 500, Carmel, California 93921.